Pen Let

Pen Lettering

Ann Camp

Dryad Press Leicester

Fifth edition, 1978

Reprinted 1979

85219 129 4

Printed in England by Hemmings & Capey (Leicester) Ltd., Ireton Avenue, Leicester,
for Reckitt & Colman Leisure Limited.

Contents

Foreword

A number of books have been written on the use of the pen in forming letters, yet all too often they appear to have been written for the student or practising scribe already familiar with the craft—so many of the important stages have been left out—so often is the meaning obscure.

The simplest action of the craftsman can become significant in the true progress of the craft; each single stage in acquiring the proper knowledge and skill must be described; a good teacher must assume that the student is ignorant until the contrary is proved.

A printed book that sets out to provide a sound working method is at a disadvantage with the spoken word. It cannot rely on subtle inflexions—repetitions—qualifications, or personal attention to the individual student. It can only set down a straightforward way of working—the author must subdue his personality to a large extent in order to define basic principles—he must assume the enthusiasm of his reader, and in a text book, one clearly defined action or diagram is worth several pages of enthusiasm.

In this book the author has set out to explain every action in every stage of learning to use the pen, from the making of letters to spacing words, planning and designing a page, and from there to planning a book.

For those who teach and wish to refresh their minds on a direct and clear approach, this book will be invaluable, and for those who wish to become proficient in the craft of pen lettering each stage is clearly explained.

The author is a professional scribe with a growing reputation and has some nine years' teaching experience behind her. Her care in producing this book is evidence of her own high standards and enthusiasm for a craft that contains as much beauty and can be as far reaching in its effects as any of the arts.

JOHN FARLEIGH 1957

Note on the Author

Ann Camp studied lettering with M. C. Oliver at Hampstead Garden Suburb Institute, and later with Dorothy Mahoney at the Royal College of Art. She is a professional scribe, a member of the Society of Scribes and Illuminators and has taught in a number of Art Schools since 1948.

At present she is a part-time lecturer at Digby Stuart College, Roehampton Institute of Higher Education.

Introduction

Pen lettering or formal writing is perhaps more bound by convention than most of the crafts because of its purpose, which is that it should be read. The letter forms must be easily recognised and understood so that their meaning can be clearly conveyed. The alphabet as we know it was not designed in any one period; it developed gradually through the ages under the influence of the broad pen. The broad pen is the tool responsible for the thick and thin strokes in lettering, creating them naturally without appreciable variation of pressure, and therefore a study of pen lettering gives an understanding of letter forms obtainable in no other way.

The clear and magnificent Roman inscriptions from which our western alphabet has grown, must have been painted or "written" onto the face of the stone with a square-ended brush before being cut with a chisel.[1] The form of these letters and their distribution of thick and thin strokes was almost certainly influenced by contemporary formal writing, although no manuscripts in written Roman capitals of so early a date as the most famous Roman inscription have survived.

Roman inscriptions and books were made in capital letters only. When the scribe wrote these Roman capitals with speed they underwent certain modifications. These modifications combined with the influence of everyday handwriting brought about the development of the small or minuscule letter. An analysis and study of historic hands provides a most valuable training for those who wish to become professional scribes, but the first thing is to know something of the alphabets of today and how to handle a pen. The student must be aware of the

[1]Research by Edward M. Catich has convincingly suggested that the square-ended brush used for "writing" the letters onto the stone before incising, was the main influence in developing the forms of inscriptional classical Roman letters, and that the chisel contributed very little, it being merely the instrument for cutting, or fixing in a more permanent form the brush drawn shapes. *See Edward M. Catich "The Origin of the Serif", the Catfish Press, Davenport, Iowa, 1968.*

practical problems of the craft before he can benefit fully from the study of ancient hands. Tradition cannot be ignored but current needs are equally important and contemporary pen lettering should never look archaic.

The aim of this book is to assist the reader to become aware of good proportion in letters, to be able to write them freely and arrange them well. It is only an introduction to the subject, describing alphabets written with a slanted broad pen, and simple materials and methods. Compound or built-up letters, quills, vellum and Chinese stick ink are the concern of the advanced student and the professional. The possibilities of self-expression in the art of calligraphy are unlimited but the beginner will be helped by certain rules. These rules have to be dogmatic, and the first stages in learning to write a formal hand must necessarily be slow and imitative. Rules or principles apply to the study of any craft, their function being an aid during the formative period. When a craftsman has mastered the technique of his subject (and rules are part of the technique) he feels the need for individual expression. He is no longer conscious of the rules as a controlling factor. He has absorbed them to train his hand and eye, and to clear his mind and make it capable of self-criticism. With knowledge he may ignore all rules to achieve his object.

This means that in an advanced stage lettering should not be an act of reproducing alphabets by blind copying, it should be a personal interpretation which is the result of thoroughly understood basic principles. All this book aims to do is to set out a system of basic principles.

Though it requires considerable application, it is not so difficult as is generally supposed to produce a small manuscript book or a well set out page of formal writing, the making of which will set their own problems and encourage a love of craftsmanship. W. R. Lethaby says in his preface to Edward Johnston's *Writing and Illuminating and Lettering*—"I doubt if any (art) is so generally fitted for the purpose of educating the hand, the eye and the mind as this one of WRITING".

Legibility

Legibility, which has been described as "a certainty of deciphering", is achieved not only by deliberate control of letter forms but also by what the eye is accustomed to reading. The standard of legibility in modern formal calligraphy is inevitably affected by the standard set in contemporary printed books, which form the greatest part of our reading matter. Most English books are printed in upright letters generally known as Roman, the text being set in small or minuscule letters, typographically described as "lower case". Capitals and italics are generally used for emphasis or for special parts of the text. Italics, being less quickly read than Roman lower case letters are often appropriate for poetry; they can also be used in prose when speed in reading is not essential but long texts in italic can be somewhat tiring to read.

Calligraphy should in no way attempt to imitate typography but it should aim to achieve a similar clarity. The student would therefore be well advised to learn to write a pen-made Roman alphabet first (both small and capital letters) and later to supplement this with a suitable italic hand.

The arrangement and spacing of letters are just as important as the individual letter unit. In quick reading the eye is apt to take in words or even phrases at a glance, therefore the letters must be so arranged that they become component parts of the word as a whole. The words must be spaced so that the eye can run comfortably along a line, and so from one line to the next without interruption; this can only be achieved with practice.

The letter forms must never obscure the meaning which is the first consideration (unless the intention is primarily one of making a design out of letters, rather than of reading them).

The Alphabet in Skeleton Form

An understanding of form is necessary before being able to write an alphabet which contains both unity and sufficient distinction between the letters to be able to identify them instantly. An alphabet based on a circle and closely related to Roman proportions gives the clearest analysis.

The skeleton alphabet is given here as a key to proportion, form, and the basic characteristics of letters. It is set out on a geometrical basis to give a clear picture of the way in which letters are related, but this geometrical basis is only a working guide and skeleton letters should be freely and directly written with a soft pencil, never tentatively or mechanically drawn (see Figs. 7, 9 and 12). The essential form is more obvious in a single stroke letter without serifs than in a more highly finished letter, and it is well worth spending a little time in getting to know the skeleton alphabet before handling a pen.

Relative proportion of capitals to circular O

FIG. 1a

RECTANGULAR LETTERS H A V N T X Y Z U

These letters are the width of a rectangle which is the same area as a circle; that is, the rectangle is slightly more than ¾ of the width of the square containing the circle.

The cross stroke of A is slightly below centre, to produce balanced counter spaces inside the letter. The curve of U follows the lower curve of the circle inside the rectangle.

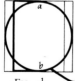

FIG. 1b

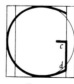

FIG. 1c

ROUND LETTERS O Q D C G

O is a full circle. Q is also a full circle with a tail added. D is the left-hand line of the rectangle,

then horizontal at the bottom and at the top following the full right-hand curve of the circle from *a* to *b* (Fig. 1b). **C** and **G** are almost a full circle, omitting only that part cut off by the right-hand line of the rectangle. Fig. 1c shows how the curves flatten towards the open side of the letter. **G** has a right-hand upright (*c-d* on diagram) and sometimes a horizontal cross-stroke at the top of this upright.

FIG. 1d

WIDE LETTERS **W M**

W is like two V's touching at the top centre point. **M** is like a V in the centre; the outside arms are the letter-height apart at the bottom; i.e. the skeleton **M** is contained in a square.

NARROW LETTERS
B P R E L F K S J

All these letters except **L** and **J** are divided at a point near the centre, so that they may be thought of as two

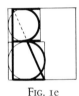

FIG. 1e FIG. 1f FIG. 1g

small letters, one on top of another. Being half height they are reasonably enough half width, thus maintaining their relation to the circle.

The division (except possibly in **P** and **R**) is slightly above centre to avoid an appearance of being top heavy. This makes the lower bow of **B** slightly larger than the upper bow (Fig. 1e). In **E** the top and centre arms are the same length; the bottom arm is slightly longer. In **F** the two arms are the same length.

The two arms of **K** form a right-angle touching the upright a little above centre (Fig. 1f).

S and **J** are shown in Fig. 1g.

VERY NARROW LETTERS **I J**

J is a variable letter, sometimes going below the line of the other letters. It is mentioned in the above group.

FIG. 1h

13

FIG. 2a

Two uprights far apart

FIG. 2b

Upright and curve nearer

FIG. 2c *Two curves nearer still*

Spacing capital letters

Spacing cannot be worked out mechanically because of the varying shapes of the letters. Fig. 4b shows measured spacing giving an uneven appearance of white. Good spacing is an optically even distribution of the inside shapes of the letters and the areas of white between them. Fig. 4a shows even spacing. No exact rule can be followed, but generally two uprights should be far apart (Fig. 2a), so that the area of white between them is rather less than the width of the letter H. An upright and a curve should be rather closer (Fig. 2b), and two curves closer still (Fig. 2c), sometimes almost touching, so that the areas of white between these letters will appear optically to be the same as between two uprights.

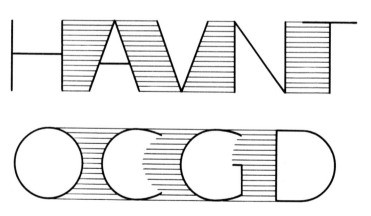

FIG. 3 *The shading indicates an even appearance of white space between the letters*

Certain letters are open on one side and set a different problem. Sometimes part of the inside shape unites with the space between letters. In such cases the next letter must be placed rather close to its neighbour, but a certain amount of judgment is necessary. See **C** and **G**, Fig. 3.

When capitals are used alone, the lines may be one letter or one half letter-height apart. When they are used with a text of small letters, the ruling for capitals should relate to the ruling for the rest of the text (see Fig. 64). Short lines may be closer together than long ones. Rather less than the width of an **O** is left between words.

EXHIBITION

FIG. 4a *Optically spaced, with an even appearance of white between letters. In even spacing the eye can travel with ease along the line*

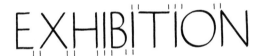

FIG. 4b *Spaced by measurement, with an uneven appearance of white between letters. This spacing causes dark and light areas in the word and the eye travels with an irregular movement, fast over the packed areas and slower over the open ones, thus impairing legibility*

Writing the skeleton capital

Materials: Hard pencil (H) for ruling lines
Soft pencil (B or 2B) for drawing the letters
Ruler
Smooth paper (not smaller than about $10\frac{1}{2}$ in. ×
$16\frac{1}{2}$ in.). Dryad white writing paper, size $16\frac{1}{2}$ in.
× 21 in. is good, or a layout pad may be used.

First study the diagrams shown in Figs. 1a to 1h in the preceding pages. These explain the widths of the letters in relation to one another. Fig. 7 shows the complete alphabet freely written.

On a smooth sheet of paper rule lines $\frac{3}{4}$-in. apart. This is the height of the letters in the geometric diagrams. The lines should be lightly ruled with the hard pencil. With the soft pencil write the letters of the rectangular group, Fig. 1a, freely and directly between the top lines of the ruled page. Make sure letters are the right width and do not press too hard. The pencil should be held lightly in the hand and glide over the surface of the paper. The first attempt will almost certainly be wobbly and irregular but practice will overcome this. Write only between alternate pairs of lines, so that there is the height of the letter between each line of writing. Repeat the rectangular letters until their forms have become familiar.

Now write the same group of letters again thinking of the spacing or even distribution of white spaces. Look at the shaded areas in Fig. 3. When the spacing is understood, repeat the same process with each of the five groups of letters.

Having covered the whole alphabet in these groups, write lines of words evenly spaced (see Fig. 4a), and afterwards write sentences. Leave sufficient margin each side to prevent a feeling of "running off" the page; 1 in. should be enough at this stage.

After sufficient practice, this exercise should be carried out in a smaller size, ruling the lines $\frac{1}{2}$-in. instead of $\frac{3}{4}$-in. apart.

Relative proportion of small letter to capital

In the skeleton alphabet and in alphabets which have no serifs, or straight serifs (see Fig. 43), the ascending stroke of the small letter is the same height as the capital letter. The body of the small letter is more than half the height of the capital and a convenient proportion is:

body height — 3/5 height of capital
ascender — 2/5 ,, ,,
descender — 2/5 ,, ,,

See Fig. 5.

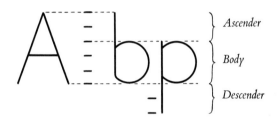

Ascender

Body

Descender

FIG. 5 *Relative proportion of small letter to capital.*

Relative proportion of small letters to circular O

The rectangle for the small letters is similar to the rectangle for the capital letters, i.e. the same area as a circle. It is important to note how curved strokes are related to the circle. This is shown in **a** and **n** in the diagram at the bottom of Fig. 6.

The joining point of the curve and the upright is rather softer and less angular in the freely written form than in the geometrical diagram. Look at the points where the right hand uprights of **a** and **n** meet their upper curves or arches in Fig. 6, and compare these letters with **a** and **n** in Fig. 7 where the forms are freely written.

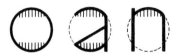

FIG. 6 *Relative proportion of small letters to circular* o. *The arches of* a, n *and other arched forms are segments of a circle*

18

ABCDEFGHIJJK
LMNOPQRSTU
VWXYZ & abcde
fghijklmnopqrstu
vwxyz 1234567890

FIG. 7

Spacing small letters

Writing lines are made three **o** spaces apart (see Fig. 8). This allows the height of an **o** for ascending strokes as in **b**, **d**, etc., and the height of an **o** for descending strokes as in **g**, **p**, etc. Since ascenders and descenders are rather less than the height of **o** this line spacing will avoid interlacing or tying up between one line and the next.

As with capital letters two upright strokes are far apart, the area of white between them is slightly narrower than the distance between the uprights of **n**; an upright and a curve are nearer, and two curves are nearer still so that all strokes appear to be equidistant.

There is rather less than the width of an **o** between words.

FIG. 8 *Lines are three* **o** *spaces apart*

19

SKELETON WRITING
observe the spacing between letters words and lines

Fig. 9

Writing the skeleton small letter

Fig. 6 shows how the small letters are related to each other; this diagram is in scale to be used with $\frac{3}{4}$-in. high capitals. The body of the small letter is 9/20-in. and ascenders and descenders 3/10-in. in height.

Rule a page for writing with the lines three o spaces apart (see Fig. 8).

For the beginner it will be helpful to rule a line at the top and bottom of the body of the letter in order to maintain an even height. Later it should only be necessary to rule a line at the bottom; this will allow for greater freedom and also train the eye to become accurate.

On the ruled page write out the whole alphabet with a soft pencil. Take care that the arched and round letters are related to the o and that they are the correct width. Keep comparing your work with Fig. 6 and Fig. 7.

Next write words and sentences, thinking of the spacing in and between the words. Look at Fig. 9. After sufficient practice, this exercise should be carried out in a smaller size, making the small letters the correct height to go with $\frac{1}{2}$-in. capitals.

When the capital letters are $\frac{1}{2}$-in. high, the body of the small letters is 3/10-in. and the ascenders and descenders 1/5-in. high.

When the small letters have been practised sufficiently, capitals and small letters should be used together. Make sure that the capitals and ascenders are equal in height.

Numerals

Fig. 7 shows numerals. 1 and 0 are the body height of the small letter. Even numbers go above and odd numbers go below the line, but they are not so tall as the ascenders and descenders of the letters.

Numerals cannot be analysed to fit a geometric pattern, but when used with a round hand they should, as far as possible, relate to a circle. Note the curves of **3** and **5**.

Write out the numerals in the correct size to go with the small letters.

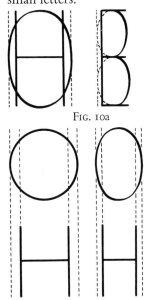

FIG. 10a

FIG. 10b

FIG. 10c

Skeleton based on an elliptical O

A skeleton based on a circle gives the clearest analysis of letter forms, because it allows the maximum difference in width between the various groups of letters.

An elliptical alphabet can be divided into the same groups of letters as an alphabet based on a circle. Fig. 10a shows the rectangular and narrow groups. O and H are equal in area, but the problem with an ellipse is more complicated for two reasons:

1. An ellipse may vary in form whereas a circle cannot alter.

2. There is less difference in width between the various groups of letters due to the narrowing of the O. This makes the grouping less obvious. Compare the two diagrams in Fig. 10b (See also p.47 and Fig. 41). In extremely narrowed forms there is very little difference between the width of O and H see Fig. 10c.

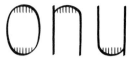

In the small letters the arches of **m, n, u,** etc. should relate to the curve of the **o.** Note the difference in Fig. 11a and 11b. Fig. 11a shows a flat formal arch on an upright letter (similar to the alphabet used in Fig. 12, which is a narrowed or compressed version of Fig. 7). Fig. 11b shows a lower branching and more springing arch on a sloped letter, more typical of italic and less formal alphabets. The **m n** arches of an italic letter sometimes spring almost from the bottom of the letter, in which case the form is in harmony with the **o** rather than being truly related. This however is a problem which applies more to cursive hands or handwriting and is not dealt with in this book.

Study the elliptical proportions before writing a compressed or italic hand. They could be practised in the same way as the skeleton based on a circle, but first learn to write a round hand as given in the next section.

ABCDEFGHIJJKLMN

OPQRSTUVWXYZ &

abcdefghijklmnopqrstu

vwxyz 1234567890

FIG. 12

22

Construction of the Roman Hand
with Double Pencils and Carpenter's Pencil

Materials: Hard pencil (H) for ruling lines
 2 HB pencils
 Sharp knife ⎱ for making double pencils
 2 rubber bands ⎰
 Ruler
 Smooth paper (not smaller than about $10\frac{1}{2}$-in. \times $16\frac{1}{2}$-in.)
 Carpenter's pencil (Wm. Mitchell's "Monk" pencils). *This is not essential but might be found useful for layouts and planning.*

How to make a pair of double pencils

With the sharp knife shave off a portion down one side of each of the HB pencils; this is indicated by the dotted line in Fig. 13a. Put the two pencils together with shaved sides touching (Fig. 13b). Fasten the pencils securely together by twisting the rubber bands round them very tightly, one band at each end (Fig. 13c). The pencils should be firmly fixed together so that they are unable to slip or wobble. The two points may be level (Fig. 13c) or a right-handed person may prefer the left-hand pencil to be slightly higher than the right one (Fig. 13d). A left-handed person will undoubtedly require the right-hand pencil to be higher than the left one (Fig. 13e). Experiments will have to be made to find the proper adjustment so that the correct writing angle can be properly maintained. An easy comfortable hold of the pencils is an essential factor in learning to write a formal hand. A cramped hold will soon tire the hand and can only produce stiff letter forms without a natural flow of writing.

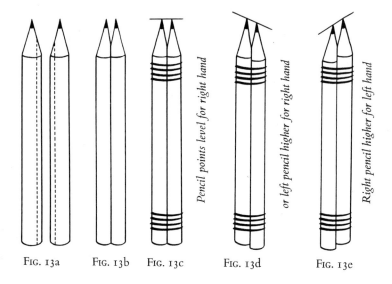

FIG. 13a FIG. 13b FIG. 13c FIG. 13d FIG. 13e

Construction of small Roman letters, numerals and punctuation marks

It requires some skill to handle an edged pen which makes thick and thin strokes, and therefore the construction of pen-made letters should be studied first with a pair of double pencils (the twin points of which represent the pen's edge). The small letters should be studied before capitals as they will form the bulk of the text.

The double pencils make an outline drawing of the letters (Fig. 15); this has the advantage of showing clearly how strokes unite with each other, either cutting or meeting at certain

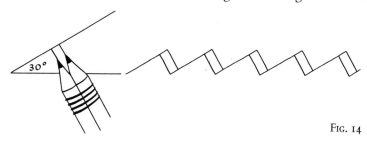

30°

FIG. 14

24

points, which is not nearly so obvious in the solid form made with the pen (Fig. 26).

Make a pair of double pencils as already explained and holding them firmly but lightly in the hand let them move freely over the surface of the paper without obvious pressure, making loops, curves, straight and diagonal lines. The two points should both draw easily and freely in whatever direction they may move. A beginner often finds that he is pressing more on one point than on the other, and that sometimes one pencil may leave no mark at all. He should practise this freedom of line, seeing that both points are drawing equally and easily before going further.

For the Roman small letter the pencils should be held at an angle of approximately 30° to the writing line; see Fig. 14. The twin points of the pencils should make a single line when moving diagonally upwards and forwards at an angle of 30° and a stroke the width of the distance between the two points when they come away from this thin stroke at right angles. This position of the pencils is kept constant throughout for the small letters, except in the diagonal strokes. A control over the pencils should be acquired before attempting to write the alphabet. Make a zigzag line and a few circles keeping the angle correct. Plenty of cheap lettering paper or a layout pad is required.

Left-handed writers may find that they cannot maintain the correct angle of the pencils when the paper is placed squarely in front of them. Tilting the paper slightly so that the top left corner is higher than the right corner will probably help considerably. (See Fig. 25c.)

The beginner will nearly always ask for an alphabet to "copy". What he should have is an alphabet to "study" so that he can understand the construction and form of letters. He must absorb the fundamental principles so that ultimately he can make a personal rendering of them.

The word "copy" has been deliberately used in the following paragraphs because in this case the first act of study is to make a copy.

Fig. 15 shows the construction of the small Roman letters. The dotted lines have been added to give a clearer indication of the solid pen form and the way in which strokes unite with each other.

The body height of the letter is four and a half times the width of the pencils. To measure this height turn the pencils so that they make their thickest stroke horizontally; make a series of "steps" similar to those shown beside the letter **a**. Having established the body height, rule a page with lines three **o** spaces apart; see Fig. 8. Leave a margin each side of the page.

The lower point of the triangular serif in ascending strokes is the same height as the capital letters, i.e. seven times the width of the pencils; see Fig. 19 and top left of Fig. 21. Ascenders and descenders are equal in height. The beginner may like to indicate these sizes by making slight pencil marks at the beginning of each line, but as soon as possible he should learn to rely on the judgement of the eye, which with practice should become very accurate.

The arrows and numbers in Fig. 15 show the order and direction of all the strokes which go to make the finished letter. It is difficult to push a broad pen upwards or backwards against its thickest edge; there is too much resistance and the ink might splutter, therefore most strokes are pulled downwards and forwards. Study Fig. 15 carefully but before attempting to copy it turn to Fig. 16 which shows the construction of a serif. On a separate unruled sheet of paper practice the serif, making sure that the strokes unite satisfactorily and that the angle of the pencils is correct. It is important to be able to make a serif properly before copying the alphabet.

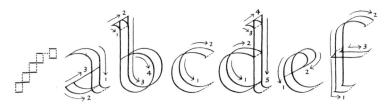

FIG. 15

26

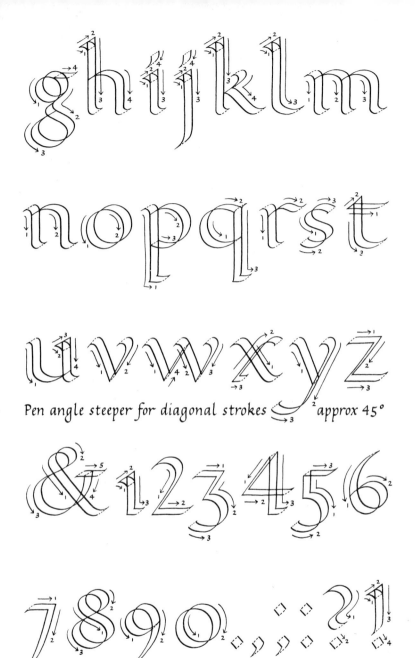

Pen angle steeper for diagonal strokes approx 45°

FIG. 15 cont.

27

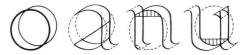

FIG. 16 Making a triangular serif. *The serif is made in three strokes which must unite neatly together. Strokes 2 and 3 may if preferred be made in one movement without lifting the pen*

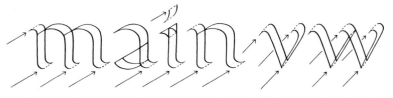

FIG. 17 The letter **o** and related forms
*One line in **o** is stressed to indicate more clearly that both lines are circular. The dotted lines over the **a** complete the letter **o**, and show how curves are related in these and other arched forms. A circle has been superimposed on **n** and **u** showing that the inside line of the arch is a segment of a circle; the shaded areas are therefore similar to each other*

FIG. 18 Angle of pencils: *constant at 30° except for diagonal strokes where it is approximately 45°.*
The arrows in this diagram indicate the angle of the pencils. Note that this angle is exactly the same at the beginning and end of strokes

FIG. 19 *The lower point of the serif is the same height as the capital.*

Now look at Fig. 17. This explains the relation of the letters to a circle. Copy the letters in this diagram on to the ruled page. Compare them with the diagram. It may be helpful to draw a circle over your letters with a coloured pencil to see if they are correct in form. When these letters have been practised sufficiently look at Fig. 18 and copy the word "main". Great care

FIG. 20 *Carpenter's pencil*

must be taken to keep the angle of the pencils constant, and a proper relation to o must be maintained in the arched strokes.

Change the angle of the pencils to 45° and copy v and w. When these are satisfactory turn back to Fig. 15 and copy the whole alphabet. Compare your work frequently with the diagram and remember not to press too hard.

The letters should be perfectly upright. It is a common fault with beginners to write with a slight backward slope. This may be corrected by ruling faint vertical lines on the page (from half to one inch apart) before starting to write; these will serve as an optical guide, but it could become a bad habit to rely on vertical ruling.

Words and sentences should be written at an early stage to encourage a rhythmical flow of writing and to develop a sense of grouping letters.

The angle of the pencils for the numerals is also 30°, but they must be held steeper for the diagonals which occur in **2, 3** and **4**. The angle of the pencils remains at 30° for **7**. Copy the numerals and the punctuation marks in the same way as the alphabet. Note that the numerals do not go as far above or below the line as the ascenders and descenders of the letters. Compare the heights of **2** with **b**, and **3** with **g**.

Carpenter's Pencils

Some students may like to write with a carpenter's pencil sharpened to a chisel edge before embarking on pen and ink. Fig. 20 shows the first letters of the alphabet written in this way.

Carpenter's pencils are sometimes useful for making a rough layout drawing for large work, but they are not accurate enough for small work.

Spacing small Roman letters

The spacing for the small Roman letters is the same as for the small skeleton letters based on a circle. This is given on page 19. See also Fig. 28.

Construction of Roman capitals and numerals

Fig. 21 shows the capital letters and numerals. The following points should be noted when writing them.

CAPITALS

1. The height of the capital letters is seven times the width of the pencils, as shown below in Fig. 21 (top left) and

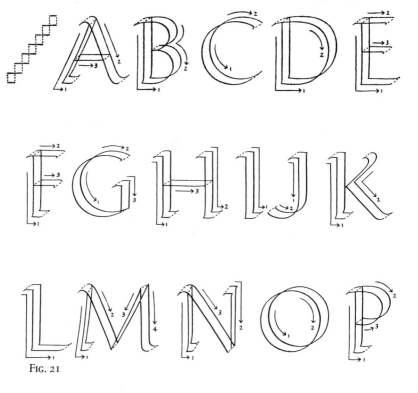

FIG. 21

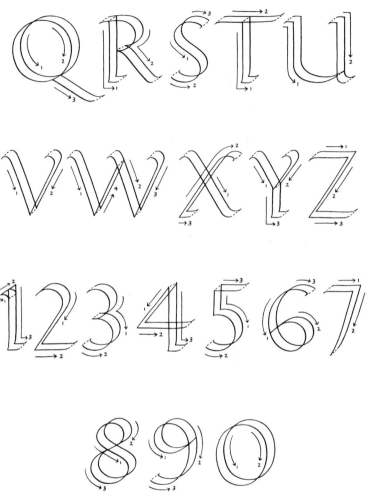

Fig. 21 cont.

the tops are level with the lower point of the serif of small letters (see Fig. 19).

2. The angle of 30° is less constant than in small letters.

3. For the broad diagonals in **A M N V W X** and **Y** the pencils are held at an angle of about 45°.

For some of the thin strokes in these letters they are held at an even steeper angle; this is necessary in order to maintain a proper balance between thick and thin strokes. Study the diagrams carefully.

Note particularly that the pencils are held slightly steeper for the thin diagonal stroke in **A** and much steeper for the thin strokes in **M** and **N**.

4. The pencils are held rather flatter than 30° for the tail of **Q** to avoid too thick a stroke.

5. They are held slightly steeper than 30° for **Z** to emphasise the cross strokes.

NUMERALS (all the same height)

1. In **2** and **4** the pencils are held steeper for the diagonals. The **3** in Fig. 21 has a rounded top and for this the angle remains at 30°. If a diagonal form similar to the **3** in Fig. 15 had been used the angle would have been steeper.

2. In numerals which are all the same height, **0** is generally narrower than a circle. This gives a better balance of weight with the other numerals and also makes it different from the letter **O**.

Copy the capital letters and numerals, leaving the height of the letter between each line of writing.

Take care that the letters are correct in width. It is a good exercise to write them in the groups given for the skeleton capitals, i.e. rectangular, round, wide, etc.; so that they can be easily compared with each other. It is also a good exercise to write out letters of similar construction together, e.g. **A M N**, **B D P R, E F**, etc.

As soon as possible write words and sentences; also write capitals with small letters using each in their proper place.

Spacing Roman capitals

The spacing of Roman capitals is the same as for skeleton capitals based on a circle. See Figs. 2a to 4b.

The Roman Hand

Materials

PENS

William Mitchell's Round Hand Pens. These are available with square, oblique and oblique reverse edges (see Figs. 22a, b and c). There are thirteen different sizes. The widest is 00, the narrowest is 6.

It is a matter of choice whether a right-handed student prefers a square or an oblique nib but for the left-handed writer the problem is more complex. Some may find that the oblique reverse nib is not oblique enough and that it involves either an uncomfortable pen hold or a slight tilting of the paper, or both, in order to produce the correct angle. (See Figs. 23c and 25c.) Unfortunately pens with steeper oblique edges are not available but it is possible to grind a nib to any required angle by patient rubbing on a fine oil stone. Fig. 22d shows an angle which would be more easily handled by most left-handed writers. Care must be taken to keep the diagonal edge absolutely straight: if it is at all curved it will not write well. Also avoid getting it burred or over-sharp or it might cut into the paper. A number of experiments must be made in order to get the nib just right. It might be argued that quills are more convenient for left-handed writers, but once the student has prepared a number of nibs which suit him, they will last a considerable time if they are properly looked after, whereas quills need continual re-cutting which might delay progress.

 Right-hand Left-hand

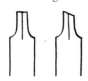

a. Square b. Oblique c. Oblique d. Oblique reverse
 reverse sharpened to a steeper angle

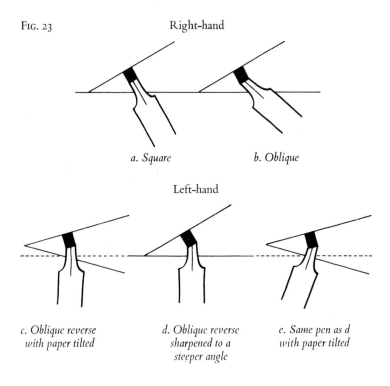

FIG. 23 Right-hand

a. Square b. Oblique

Left-hand

c. Oblique reverse d. Oblique reverse e. Same pen as d
with paper tilted sharpened to a with paper tilted
 steeper angle

Fig. 23 shows the different pen positions to produce an angle of 30°.

William Mitchell's Rex Pens No. 0906-0916. These are only made with one edge which is very slightly oblique. There are eleven different sizes. The widest is size 1, No. 0906, the narrowest is size 6, No. 0916.

These are just two of many suitable makes of pen which are available. Note that pen sizes from different manufacturers vary considerably and a size 1 in one make may be much wider or narrower than a size 1 in another make.

PEN HOLDER. It is important to select a pen holder with a good round barrel. Some holders are semi-circular in section where the nib fits in; these are unsuitable as they are too difficult to hold at the correct angle.

FIG. 24 *Reservoir pen holder*

Reservoir holders may be helpful (see Fig. 24), so that the pen can hold more ink, but they are not essential.

INK. Winsor and Newton's non-waterproof black ink is good. Do not use a waterproof ink; it will not flow freely.

BRUSH. A water colour brush is necessary for feeding the ink into the pen. It is best held in the left hand so that it is always ready to re-fill the pen. The ink pot should be to the left of the board so that the brush can be dipped into it easily.

RAG. Always have a clean piece of rag handy for cleaning the pen. As soon as the ink seems to clog, the pen should be wiped. Nibs must be kept clean and shiny; the ink will not flow properly when the nib is dirty.

WATER. A water pot is necessary for washing the ink brush.

PAPER. Any smooth not too highly glazed paper is suitable. Dryad white writing paper is good and was used for all the diagrams in this book. For advanced work a good quality hand-made paper is best. A spare piece of paper similar to the sheet being worked on should always be kept close at hand for pen trials and calculations.

WRITING BOARD OR DESK. This must be sloped at an angle of about 45°, so that the student can sit comfortably in front of the work and see it clearly (Fig. 25a). A hinged board is best, but an ordinary drawing board resting in the lap and supported against the side of a steady table will prove satisfactory. Do not write on a flat desk; it involves bending over and the ink will run out of the pen too quickly because of the necessity of holding it almost upright. Note the position of the pen in Fig. 25a. In this position the flow of the ink can be easily controlled.

For a right-handed student the light must come from the left; a good light is necessary, but avoid direct sunlight.

The board should be set up as shown in Fig. 25b. A pad of paper covers the board; newspaper will do if the folds are flattened and it is covered over with a piece of white paper. It is difficult to write on a very hard board, and this pad makes a comfortable writing surface.

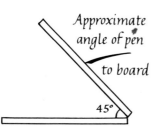

FIG. 25a

FIG. 25b

FIG. 25c

The writing paper is not pinned down but is held in position by the guard sheet, which is securely pinned or taped at each corner to keep it taut. Push the drawing pins right into the board so that they do not get in the way of the hands while writing.

Always write at the same level, pushing the paper up after the completion of each line. Each student must find his own writing level, fixing the guard sheet so that he can write comfortably just above it. The guard sheet as its name suggests helps to keep the writing paper clean.

A left-handed writer, as already mentioned, may find that a slight tilt of the paper is helpful in maintaining the correct angle of the pen. This is shown in Fig. 25c.

FOR RULING LINES the following will be needed: Ruler, Set Square, Dividers, H Pencil.

36

Writing the Roman hand

The best writing instrument for manuscript work is a well-cut quill; reed pens are good for large writing. The cutting of quills and reeds is quite an art and requires a sharp knife with a bevel on one side of the blade only.

The best ink is a good Chinese stick; this requires careful rubbing down.

These materials, although the best for the production of fine work, involve certain complications and the beginner will get on more quickly with metal nibs and bottled ink.

Look at the alphabet shown in Fig. 26. With your widest pen, which should not be less than 1/10-in. wide, measure the body height of the letter (four and a half times the width of the pen). Rule a page with lines three o spaces apart (see Fig. 8) leaving margins at the sides, top and bottom. Make the side and top margins rather wider than the distance between lines, and make the bottom margin about twice the width of the top one. Study the alphabet in Fig. 26 in the same way as explained on page 26 for double pencil work. The letters should be freely and directly written on to the ruled page.

The letters are based on a circle which forms the dominating rhythm of the hand but a free rendering of a circle is better than mechanical precision, provided the departure is not too great. The rhythmical flow of the writing is just as important as the individual shapes of the letters. The alphabets in this book have been very carefully written in order to provide model letters of good proportion and construction, and are therefore lacking in freedom.

Fig. 27 shows how awkward combinations of letters may be written. The tail of r may run straight on into a, i and v without lifting the pen. Care must be taken to see that there is a thin stroke at the joining point. If the stroke becomes thick at the joining point legibility will be impaired. When r runs into i it is not necessary to give i a triangular serif; including it might cause too much weight. The cross strokes of t and f may be conveniently joined in double letters. In the case of ff the top

abcdefgh
ijklmnopq
rstuvwxyz
123456789
gy&ɣ

FIG. 26

38

æ ra rí rv tt

ff fl Th Æ

FIG. 27 *How awkward combinations of letters may be written*

arches may also be joined, but if they are, the first arch should
be lower than the second one. Where f joins l the arch of f may
be narrowed and run straight into the serif of l. Care must be
taken not to make this point too heavy. A capital T may run
into h; the latter does not then need a serif. As the student
progresses he will discover other ways of fitting letters together.
Small and capital diphthongs are given.

Fig. 28 shows spacing. Always aim at an even pattern of black
and white. The spaces between the letters should look about the
same size as the white shapes inside them. Train the eye to look
at the inside shapes of letters and see that they are kept regular.

mountain

FIG. 28 Spacing. *An even distribution of white inside and between letters*

ABCDEF
GHIJKLM
NOPQRS
TUVWX
YZ & 1234
567890

FIG. 29

40

When the student feels he can write this alphabet sufficiently well with the widest pen he should select a narrower one and write smaller, always measuring the height of the letter by the width of the pen. It is a mistake to write small too soon as the faults will be less obvious in small work and it is easy to get into bad habits. As soon as possible select a passage to write out; this provides a much better training than the writing of individual letters or words.

The lines of writing should form strong regular bands of pattern interspaced with bands of white. Care must be taken not to place words too far apart. Wide spaces between the words will give an appearance of "rivers" running down the page, and the strength of the line will be spoilt.

Practice the alphabet shown in Fig. 26 thoroughly before studying the capitals in Fig. 29. The latter should be studied in the same way as for double pencil work; see page 30.

The importance of knowing this alphabet of small and capital letters really well cannot be over-emphasised. It is the basic hand from which all variations of form and weight may spring, and for this reason Edward Johnston named it the "Foundational Hand."

A Single Page

So far the student has been concerned with the problems of learning to write a formal hand. He has left only sufficient margin to prevent a feeling of "running off" the page. Now he should think of margins as an essential part of the design and layout of his work. The following exercise, giving an exact size of page and margins, can be carried out quite easily without involving many calculations.

Cut a piece of paper to measure 14 in. × 18 in., making sure that the corners are square. Rule in the side and top margins, making each of them $2\frac{1}{2}$ in. in width (Fig. 30): this will produce a text column 9 in. wide. Measure 4 in. for the foot margin and indicate this width with a light pencil mark, but do not rule a line.

Take a size 2 Round Hand pen and on a trial sheet of paper measure four and a half nib widths to find the letter height. This will be about 9/32 of an inch (just a little more than a quarter of an inch). Remember that pen sizes vary according to the manufacturer; if a pen of a different make is used select one which will produce a similar thickness of stroke.

Next work out the line spacing, which is three o spaces apart as shown in Fig. 8. Set a pair of dividers to this width and "walk" them from the top margin line down each of the vertical margin lines until they come to the pencil mark for the foot margin. The last line may occur just above or just below this mark whichever is closer to it. Rule in the lines as shown in Fig. 30. There should be fourteen or fifteen lines.

Using the alphabet shown in Fig. 26 and writing to the above measurements you should have an average of about six words to a line. If there are fifteen lines you will require a passage of approximately ninety words to fill the page. If there are several paragraphs you will require rather less words, as allowance will have to be made for the blank portions of lines which may occur at the paragraph endings.

Select a passage of the required length. Before starting on the finished page write two or three lines on a trial sheet as a check

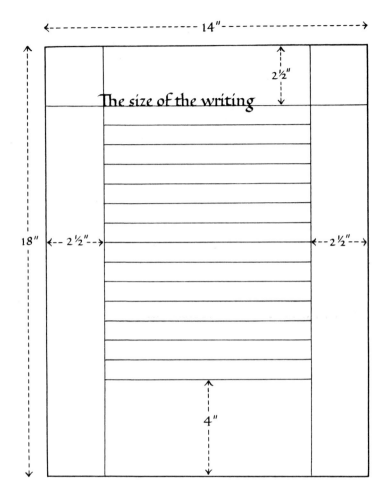

The size of the writing

FIG. 30 *A single page*

that everything will work out according to plan, and to serve as a loosening-up exercise. The finished page should be written immediately afterwards, while the hand and eye are familiar with the size and style of writing.

The left-hand edge of the text will be perfectly square but the right-hand edge will inevitably be broken. With experience, slight adjustments can be made to make this more even, but the beginner should not aim beyond good regular writing with even spacing. He should accept the irregular right-hand edge as a natural outcome of the work.

Margins for a single page

The margins given in the above exercise are of good average proportion for the shape of the page and style of writing used. Margins for single pages may however vary enormously according to the shape of the page and the weight of the writing. On a page of more unusual proportion (such as long and narrow or a horizontal rectangle) the margins can only be settled optically. There is no fixed rule of proportion which would suit every occasion but a good general rule is that the side margins should be equal in width, the top margin should be rather narrower and the foot or lower margin should be the widest of all, normally about twice the width of the top one (see Fig. 65). Even this rule would not serve for every occasion: for example, a square page would probably require less foot margin. Heavy writing and framed pieces normally require less margin than light-weight writing and unframed pieces.

Figs. 31-37 show a number of varying layouts for a single page. When a title occurs at the top of the page leave space for this and write it in last, so that it can be well placed and properly centred above the main text. Titles may be written with a wider pen or in capital letters. Make a specimen title on a trial piece of paper, cut it out and place it in position on the page. Move it about until the best position is found, then mark this position and re-write the title on the finished work.

Fig. 31 *Capitals in margin*

Fig. 32 *Capitals partly indented*

Fig. 33 *Capitals square with left-hand margin*

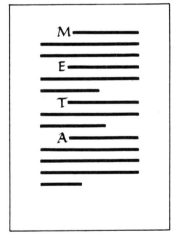

Fig. 34 *Capitals completely indented: generally more suitable for printing than writing*

45

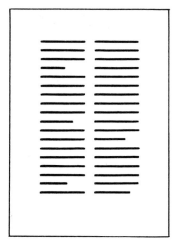

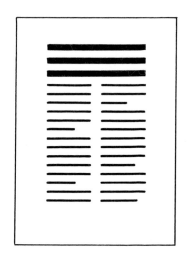

FIG. 35 *Two columns* FIG. 36 *Single column of heavy writing leading into two columns of finer text*

FIG. 37 *Horizontal panel*

Variations of Form and Weight

The student should now be thoroughly familiar with the alphabets shown in Figs. 26 and 29 and be able to write them easily and without hesitation. At this stage he should consider how the weight and form of the letters may be varied to suit different kinds of work. Three variations are given in Figs. 38 to 44. These alphabets should be carefully studied, and a finished page should be written in each hand. When he has become proficient in these, other variations of form and weight should suggest themselves to the student, and it is at this stage that he begins to write a personal and creative hand.

Fig. 38 shows a hand which in construction is exactly the same as Fig. 26. It is written with the same pen but is heavier in weight. The body height is four instead of four and a half times the width of the nib. The ascenders and descenders do not need to be quite so tall on the heavier letter and lines may be rather closer together. In the diagram they are about two and a half instead of three o spaces apart.

Fig. 39 shows heavier capitals to go with Fig. 38. These follow the construction of Fig. 29 but are six times instead of seven times the width of the nib. The lower point of the serif of the small letters is the same height as the capital; see E b, Fig. 39.

Fig. 40 shows a heavy compressed Roman hand. The shape of the o is elliptical (see skeleton based on an elliptical o, page 21). It is written with the same pen as Figs. 26 and 38 and constructed in the same way but the form is narrowed thus creating a blacker letter. The line spacing and body height are the same as for Fig. 38 but ascenders and descenders are shorter.

Fig. 41 shows capitals to go with Fig. 40; they are five and a half nib widths in height. In a compressed capital letter which is as short and heavy in weight as this, the circular letters are more compressed than the rectangular and narrow groups, otherwise the increased weight would make the latter too heavy and the inside shapes would be too small and distorted. Note the inside shapes of A and B and of C and D and compare them

47

abcdefghijk
lmnopqrstu
vwxyz

FIG. 38

✓ABCDEb

FIG. 39

with Fig. 39. No exact rule can be followed for the proportion of compressed capital letters, and careful judgment is necessary

48

abcdefghijk
lmnopqrstu
vwxyz

FIG. 40

ABCDEF b

FIG. 41

in order to maintain uniformity. The lower point of the serif of the small letters is the same height as the capitals. See **F b**, Fig. 41.

⟋abcdefghij

klmnopqrst

uvwxyz

FIG. 42

FIG. 43

Fig. 42 shows a light-weight Roman letter with straight instead of triangular serifs. The body height (which is the same size as for Figs. 38 and 40) is five times the width of the pen, i.e. a narrower pen has been used. Lines are three **o** spaces apart. The construction of some of these letters is rather different from the construction in the preceding alphabets. Note particularly **k, v, w** and **x** and the feet of **m, n,** etc. The same pen angle is used as for the other Roman hands.

Fig. 43 shows that the ascenders and capitals are equal in height.

ABCDEF
GHIJKLM
NOPQRST
UVWXYZ

FIG. 44

Fig. 44 shows capital letters with straight serifs, to be used with Fig. 42. These letters are eight nib widths in height. The straight serifs involve a slightly different construction in certain letters; note particularly A, K, M, N, V, W X and Y, and compare them with Fig. 29.

The four alphabets shown in Figs. 26, 38, 40 and 42 will give some idea of the variety of form and weight which is possible by making slight variations upon a basic alphabet. This variation of the fundamental form is the key to a thorough understanding of pen lettering.

When the student has acquired a good Roman hand he should pass on to the study of an italic hand.

The Italic Hand

Italic writing is less formal than the alphabets given in the preceding pages. The narrowed form, steeper pen angle and slight slope are the result of writing with greater speed. Italic hands are however not always sloped; they can be completely upright. There are many varieties but only one form is given here. This has been selected as being the most generally useful.

Before attempting to write an italic hand turn to page 21 and read the section on a skeleton alphabet based on an elliptical o. Look at Figs. 11a and 11b. Fig. 11a is the skeleton of an alphabet such as that shown in Fig. 40. Fig. 11b is the skeleton of an italic hand which may be thought of as a development through speed from a compressed Roman hand. Certain italic letters differ considerably from the Roman; note the forms of *a*, *f* and *g* in Fig. 45.

Look at Fig. 45 and note the following points:

1. The body height is five times the width of the nib and two-thirds the height of capitals (see Fig. 48).
2. Ascenders and descenders are about four nib widths in height.
3. Tick serifs have been used on the ascenders of *b d h k* and *l* in the top line of Fig. 45. Two alternative forms of serif have been given in the bottom line.
4. Lines are three *o* spaces apart.
5. Pen angle 45°, Fig. 47 (except in the tail of *q* where the angle is flatter).
6. Slope of about 5°. Avoid too great a slope.
7. Numerals do not go as far above or below the line as the ascenders and descenders of the letters. Compare **2** with *b* and **3** with *g*.

Ascenders and descenders could be the same height as the body of the letter or longer still, but if this is so lines must be wider apart to avoid tying up between one line and the next. Three and a half or four *o* spaces might be used.

As already mentioned, Fig. 48 shows the height of the capital in relation to the small letters. If and when ascenders and

abcdefghijkl

mnopqrstuvw

xyz&fgyyꝺ

1234567890

bd & hkl

Fig. 45

53

descenders are longer than those shown in Fig. 48 the capitals need be no larger, but larger or flourished capitals may be used to emphasise beginnings and important points.

Fig. 46 shows the capitals. The main alphabet is a narrowed and sloped version of Fig. 29. Note the following points:

1. The letter height is seven and a half times the width of the nib.
2. The line spacing in Fig. 46 is the same as in Fig. 45.
3. Pen angle 45° (see Fig. 47), and steeper still for some strokes; note particularly the thin strokes of M and N. It is held at a flatter angle for the tail of Q.
4. Slope of about 5°.
5. Some alternative forms have been given. A few of these are slightly flourished but the beginner will be well advised to keep his work straightforward and simple and not to flourish overmuch. One or two well-chosen flourishes will give a page a decorative quality, and make a pleasant contrast to the regular bands of writing. Too many flourishes make a page look restless.

Only a sloped italic capital is shown in the diagrams, but it should be mentioned that frequently a heading can be written in upright capitals followed by a sloped italic text. The contrast can be very pleasing. The heading may be stressed even more by writing it in an upright letter of rounder construction similar to the alphabets shown in Figs. 29 and 39 (the centre line in Fig. 66 is stressed in this way). Whichever form is selected, the letters should be kept as simple as possible to make for easy reading. Flourished forms as a rule tend to be bewildering in a heading; they are more suitable for initial letters, beginnings and endings.

Study the italic hand in the same way as the preceding alphabets. Fig. 49 shows how some awkward combinations of letters may be written. As with the Roman hand, the cross strokes of t and f may be conveniently joined in double letters. The top arches of f may also be joined if the first arch is kept lower than the second; the tail of the second f is usually best if it ends in a flat serif or "foot" as shown in Fig. 49; f may run into l; r may run into i and v. Where double g occurs it may be helpful

ABCDEFG

HIJKLMNO

PQRSTUVW

XYZ AMNX

BEJHFGL

FIG. 46

55

to reduce the tails so that they do not link back on to the body of the letter, thus avoiding too much weight. Capital *T* may run into *h* and the latter may be flourished.

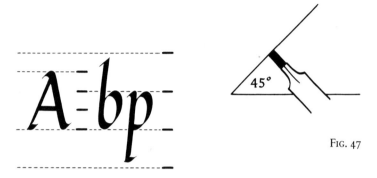

Fig. 47

Fig. 48 Relative proportion of small letter to capital
Body height = 2/3 of capital
When writing lines are three o *spaces apart (see Fig. 8), ascenders and descenders should be rather less than the body height of the small letter to avoid interlacing between the lines of writing*

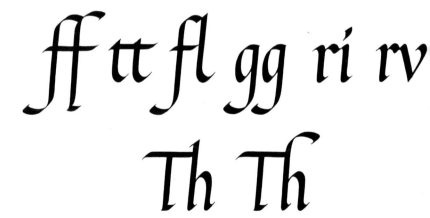

Fig. 49 *How awkward combinations of letters may be written*

Spacing the italic hand

Aim at an even pattern of black and white. This is easier with italic than with Roman hands, as the letters are all much nearer to each other in width. The curved uprights are only slightly curved and may fit into a pattern of optically equidistant parallels; see Fig. 50. The inside shapes of the letters and the spaces which occur between them should look about the same size.

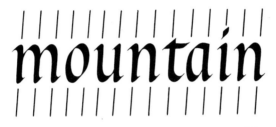

FIG. 50 Spacing. *An appearance of equidistant parallels in straight and curved strokes*

Colour

The student may now introduce some colour for headings, initials and marginal notes. This will greatly enrich the work. The most useful colours are red, blue and green and these should be clean and bright.

Students' water colours or poster colours are suitable for practice work.

Illuminators' powder colours are the best for fine work but are not recommended for the beginner who will find prepared colours more convenient. Use *artists' water colours* for finished work; these are obtainable in cakes, pans and tubes.

Cake colours come next to powder colours in purity. They can be used in the following way. Put a few drops of water in a saucer and holding the cake between thumb and finger rub it round and round gently but firmly in the pool of water until the colour is thick enough. It should be mixed to a thickness which will run easily in a pen and dry "solid", i.e. not transparent.

When the colour is mixed, the cake should be dried on a clean rag (if left wet it might crack). Before putting it away, wrap the cake in a piece of paper to keep it free from dust.

A drop of gum arabic may be added if desired. (Liquid gum arabic as supplied by Winsor and Newton is convenient). This will brighten the colour and also prevent it from rubbing off, but be very sparing with gum; too much will make the colour crack. Experiments will have to be made in order to get the best results. The colour (which must be stirred frequently) is fed into the pen with a brush. It is best to keep one brush specially for each colour.

The angle of the board should be rather flatter for colour work than for black writing. Colours do not flow quite so readily from the pen as ink does, and the slightly lowered board means that the pen shaft is somewhat elevated, thus producing a more rapid flow. The pen must be wiped frequently to prevent the colour from clogging.

Pan colours are good but *tube colours* are generally too sticky. They are however less sticky if mixed the day before writing with them. The mixed colour should be covered to keep it free from dust.

Designers Gouache colours. These colours have the advantage of being less transparent than artists' water colours. Like other water colours supplied in tubes they are sometimes too sticky, but are greatly improved if mixed the day before writing with them. Do not forget to cover the mixed colour to keep it clean.

Red. Vermilion and scarlet vermilion are the most usual reds and should both be used without adding any other colour. They are sufficiently opaque to dry flat and even.

Blue must always be mixed. Cerulean mixed with cobalt and white is good. The white adds "body", helping the colour to dry flat and even. A touch of French ultramarine may be added to the mixture, but be very sparing with this or the colour may be too purple. A good blue should be neither too purple nor too green.

Green must always be mixed. Viridian mixed with white (to give body) and a touch of lemon yellow is good. Too much yellow will make the colour sickly.

As progress is made in understanding the relationship of colour in writing, softer colours such as subtle browns and greys can be introduced. These will need to be mixed.

Coloured paper. For poster work and notices the use of coloured paper with white writing or coloured writing with sufficient tonal contrast (i.e. light colours on a dark ground, dark colours on a light ground or dark and light on a middle tone) is useful and effective. Ingres paper is one of the best and is made in a wide variety of colours. It has a pleasantly textured surface for large work but the grain is rather too coarse for small work.

A Manuscript Book

The student should now make a small manuscript book. The writing of a continuous text will provide a better exercise than the planning of a single panel or broadside.

Avoid being over-ambitious or original in the first book and keep it short so that it will be finished in some six or seven sessions. This is important because as the student progresses his standard of writing will improve and if the book is too long he may become dissatisfied with the beginning before he has reached the end. Remember also that a passage set in type may seem quite short but when it is written in a manuscript hand it spreads out considerably over the pages. A few practical suggestions are given here to help develop a straightforward and workmanlike approach.

Size of the page

This is generally controlled by the way in which the paper folds. A sheet of paper folded once is known as folio; cut in half and each sheet folded again is quarto; cut in four and each sheet folded again is octavo (Fig. 51). Paper sizes vary a great deal and so these foldings will produce different sized pages according to the paper decided upon, but a quarto folding always makes a squarish book page while a folio and an octavo folding make a rather long narrow one.[1] For direction of paper grain see page 69.

The thickness of the paper will depend upon the size and the nature of the book. A small book will obviously require thinner paper than a larger one.

FIG. 51

| Folio | Quarto | Octavo |

[1]This does not apply to the A sized papers where the proportion is constant.

Margins in books

Margins are necessary to frame the text. They are a functional part of legibility but also contribute greatly towards the design.

The two pages of an open book are thought of as one sheet having two columns of text surrounded by margins. The combined centre margins should be the same width as each of the outside vertical margins, the top margin rather less, and the foot margin the widest; the foot margin is usually twice the width of the top one. (See Figs. 52 and 55c.)

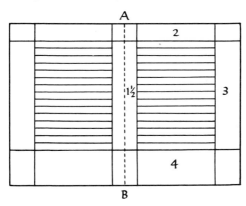

FIG. 52 Quarto Book
Unit for measuring margins is 1/16th-1/18th height of page

There are two different methods of calculating margins, one for folio and octavo foldings and the other for a quarto folding. It is suggested that the student should start with a quarto book and so the method for a page of this proportion is given first.

Quarto page

The margins are in proportion of $1\frac{1}{2}$, 2, 3, 4 (Fig. 52), the unit of measurement being 1/16th, 1/17th or 1/18th the height of the page, depending on the width of margins required: 1/16th gives wider margins than 1/18th.

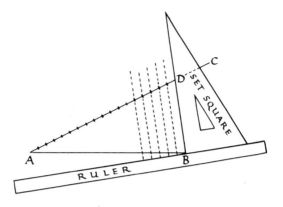

FIG. 53 *How to divide a line into a given number of parts*

Having cut and folded the book page, measure the height of it (A B, Fig. 52), and on another piece of paper rule a line exactly the same length (A B, Fig. 53). This line must now be divided into eighteen parts. Rule a line A C at not too steep an angle. It is convenient to make this line a little longer than A B. Guess a size which might be about 1/18th of A B and with a pair of dividers "walk" this measurement along A C eighteen times to D. Join B to D. Put a set square against B D and place a ruler against the lower edge of it. Hold the ruler firmly in position and slide the set square along it. Rule lines against the side of the set-square through each prick made by the dividers down to the line A B. This is indicated by the dotted lines in the diagram. A B is now divided into eighteen equal parts and the unit for measuring the margins has been established. By this method a line may be divided into eighteen or any other given number of parts.

Cut and fold a trial sheet of paper to exactly the same size as the finished book page, making certain that the corners are square. The margins must now be ruled in on this sheet in order to find the text area. The folded sheet should be opened flat so that the two facing pages can be ruled together.

Margins, as already mentioned, are in proportion of $1\frac{1}{2}$, 2, 3,

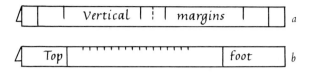

FIG. 54 *Paper scale for ruling the book pages*

4 (see Fig. 52). With a pair of dividers, measure one and a half units for each of the centre margins and three units for each of the outside vertical margins. Rule in these lines from the top to the bottom of the page. Next measure two units for the top margin and four for the foot margin. Rule in these lines as shown in Fig. 52. The text area has now been established. Do not rule any of the finished book pages until the line spacing has been worked out.

The size of writing and how to rule the page

For a round Roman hand between four and eight words to a line is a good general rule. When an italic hand is used rather more words might go to a line. Experiments will have to be made on a trial sheet to find a convenient size of writing to fit into the established text column. At first this may take some time and several attempts might have to be made before a suitable size is found. With practice the student soon becomes very good at guessing which pen to take and he can calculate quickly what is required. All trials should be kept with a note to say which nib was used; these may be useful for reference later.

Having decided upon the size of the writing, the line spacing must next be worked out to suit the selected hand and a paper scale (Fig. 54) is made so that all pages can be accurately ruled. The scale should be made on a piece of folded paper rather longer than the width of the open book. The measurements are accurately marked along the folded edge with a hard pencil. One side of the scale (Fig. 54a) is marked with the widths of the

vertical margins; the centre fold must be indicated so that the scale can be correctly placed on the book page. The other side (Fig. 54b) is marked with the height of the page, the width of the top margin, the line spacing and the foot margin. Mark the height of the page and the widths of the top and bottom margins first, then set a pair of dividers to the correct line spacing and "walk" them along the edge of the scale from the top margin down. Any extra margin (if the ruling does not fit the calculated height of the text column exactly) is left at the bottom, or the last line may slightly encroach into the lower margin. When the paper scale has been made, the finished book pages can be ruled.

If deckle edged paper is used the deckle edges should occur at the sides and at the bottom of the book. The top edge is always clean cut and must be accurately squared with the centre fold so that measurements can be taken from the centre outwards and from the top down. Another practical reason for this is that the book when closed will have a flat smooth surface on top and dust will not penetrate between the leaves when it is standing upright in a book-shelf.

Place the paper scale on the open book page and mark the widths of the vertical margins at the top and bottom of the page. Rule in these lines. Turn the scale over and place it in the correct position against an outside vertical margin and mark the position of the writing lines, then mark the other outside vertical margin in a similar way. These marks should be inside the vertical, i.e. not in the margin, and should be imperceptible when the writing lines have been ruled in. Rule the writing lines, preferably across both pages with a long ruler, but do not rule them across the centre margins, except possibly the top and bottom lines (see Figs. 52 and 55c) which may if you wish run to the limits of the page. When one side of the sheet is ruled, turn it over and rule the other side to match. The four corners of each text column can be lightly pricked with a fine needle so that the ruling of the reverse pages will correspond exactly. Care must be taken to rule neatly and accurately with faint lines. These lines are not rubbed out; they are left as a structural

part of the page. Clumsy ruling may ruin the appearance of an otherwise good piece of writing.

Folio and octavo pages

The text area is equal to 2/5ths the height of the page (Fig. 55a). Put this area into a vertical position (Fig. 55b) and divide both the top and the side margins into three equal parts as indicated in the diagram. One part of the side margin in Fig. 55b is then taken as the width of each of the centre margins in Fig. 55c and two parts for the width of each of the outside vertical margins. One part of the top margin in Fig. 55b is taken for the top margin in Fig. 55c and two parts for the bottom margin. The margins and text area are now settled.

Folio and Octavo Book

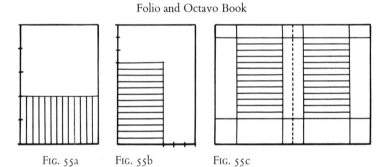

FIG. 55a FIG. 55b FIG. 55c

If deckle edged paper is used for an octavo book, fold the full sheet of paper as for a folio book and carefully tear along this fold so that there are two sheets with similar edges all round. Each of these sheets is then cut cleanly in half and folded for the book page. The top edge is always cut square with the centre fold. Deckle and torn edges are arranged alternately throughout the book to make for an even appearance. A mixture of deckle and clean cut edges is not so pleasing.

The size of the writing and line spacing are worked out in the same way as for a quarto page (see page 63).

The make-up of the book

It is not possible in this book to deal with more than a simple single-section book, which is sewn into a stiff paper cover. Fig. 56 shows the make-up of such a book, which comprises:

1. Text
2. Title page
3. Fly leaves (these serve as margins to the whole book)
4. Cover

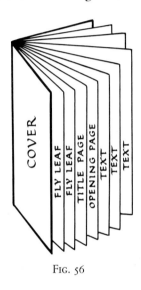

FIG. 56

Before starting a book, calculate the approximate number of words to a page, and then calculate the number of pages required for writing out the chosen passage. It is not possible to make an exact calculation and it is better to have too many pages than too few. An extra blank page at the end of the book will not matter, but the appearance is spoilt if there are no blank fly leaves at the end.

Rule all the pages before starting to write. Place the folded sheets inside each other and number them lightly in pencil to avoid writing on the wrong pages. The first half of the book is written on the pages to the left of the centre fold, and the

second half of the book is written on the pages to the right of the centre fold.

The first page traditionally occurs on the right-hand side of the book. The opening can be stressed in a number of different ways. Look at Figs. 58, 59, 60, 64, 65 and 67. Keep the first book as simple as possible and avoid too much planning.

The title page, also on the right, can be more elaborate than the opening page and is designed when the text is completed. It should not overpower the text or be out of harmony with the book as a whole. It generally faces a blank sheet and is placed so that it appears to be vertically central on the page. To achieve this, place the design slightly nearer to the centre fold than to the outside edge. The top and bottom margins may follow those of the text or they may be wider. Remember that the bottom margin is always wider than the top margin.

Look at the title page of this book. This has been kept simple in design and layout because it is the opening of a printed book. An elaborate design would have been out of place.

When the title page has been written, place the completed book sheets inside each other and place these inside the folded title sheet. At least two extra folds of blank paper encase a single section book; these are known as fly leaves. Cut and fold these sheets and place the book inside them.

The book is now complete except for the paper cover, and this should be sufficiently stout to protect and hold the book together. It should project about an eighth of an inch beyond the leaves of the book. The title is written upon it; this can be more decorative and bolder than the one shown on the title page. The lettering may be the only ornament, or the cover may be enriched in some way. A good method is to cover the background with an abstract pen design, suited to the subject matter of the book.

The cover can be varnished to prevent it from smudging. There are a number of suitable paper varnishes which may be used; select one which does not give too much gloss. The varnish can be sprayed or painted on, but care must be taken not to let the colours run. Make some experiments before

applying varnish.

When the cover is completed, place the folded book sheets inside it, and sew the whole book together with one set of stitches as shown in Fig. 57. Make sure that all the top edges of the pages are level before placing them inside the cover. Using fine thread and a strong needle, start and finish sewing in the centre of the book, passing the needle through five holes as shown in the diagram. Pull the thread tight, and tie the loose ends over the long centre stitch. Cut the ends about a quarter of an inch beyond the knot. When this is done the book is finished.

A first book is something of an experiment, but it will present some of the problems which are likely to occur in manuscript work. The second book may be approached with more confidence and can be more elaborate in design and include illustrations or decoration.

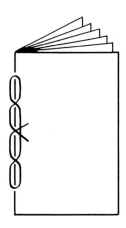

FIG. 57 *Sewing a single section book together*

The method of folding paper for making manuscript books as given on page 60 does not take into account traditional binding in a hard cover where the end papers are pasted down.

If the book is to be bound in a hard cover, it is important that the grain of the paper runs parallel with the spine to avoid the book warping in the wrong direction. If hand-made paper is used, this problem does not arise as the grain has no specific direction.

Figs. 58–67 in the following pages are self-explanatory diagrams dealing with the weight of writing, layout and arrangement.

A CONTRAST
of size may be achieved
by writing one or more
lines in large CAPITALS ☀
with the same pen as the
rest of the text

Fig. 58

A CONTRAST
of size & weight may be
achieved by writing one
or more lines in capitals
with a wider pen

Fig. 59

☀ This word was written with a smaller pen

A contrast

of size and weight may
be achieved by writing
one or more lines in the
same letter form but
larger and with a
wider pen

Fig. 60

Short lines of
heavy writing
may be close
together; this
gives a rich &
almost Gothic
appearance

FIG. 61

Longer lines of the same
form of writing would
need to be slightly wider
in their line spacing to
maintain legibility

FIG. 62

The lighter weight Roman letter requires wider line spacing because the contrast between the lines of writing & the interspaces of white is not so great Fig. 63

A PIECE OF WRITING
MIGHT BEGIN WITH
SEVERAL LINES OF
CAPITALS

These capitals could be in black
the same as the text, or they could
be in colour, Red, Blue or Green.
The text must be carefully stud-
ied first and emphasis only be
made where it assists the mean-
ing. It is wrong to emphasise any
part of the text for decorative
reasons alone.

The two pages of an open book are

Fig. 64

thought of as one sheet, having
two columns of text surrounded
by margins.
The ruling for an 'opening' as set
out opposite should relate to the
lines of the main text; this will
avoid over complicated problems
in layout and planning.
A convenient number of words
to a line for both reading and
writing is between four and
eight. The spaces between words
are a little less than the width
of the letter 'o'.

On these two pages 2/5 the height of the page = text area.

FIG. 65

SOMETIMES a passage may begin with a two or a three line Capital leading into a word in smaller Capitals and then into the selected text. Following paragraph beginnings might be emphasised with a Capital letter set in the margin. On a single page of writing the side margins are equal in width, the top margin is usually rather narrower and the lower margin is the most generous. It is most important to have a wide lower margin otherwise the text will appear to be 'dropped' on the page. The width of the margins depends on the shape of the page and the weight of the writing.

FIG. 66

For
poetry and
symmetrical or centred
arrangements of
↶WRITING↷
an italic hand
is usually
best

✤

In the making of
the Written Book,....
the adjustment of letter to
letter, of word to word, of pic-
ture to text & of text to picture
and of the whole to the subject-
matter and to the page admits
of great nicety and perfection.
The type is fluid & the letters
and words, picture, text and
FIG. 67 page are conceived of as one

and are all executed by one
hand, or by several hands all
working together without
intermediation on one ident-
ical page and with a view to
one identical effect.

T.J. Cobden-Sanderson

Conclusion

This book has described the construction of letters, using the simplest pen movements. With practice one gains dexterity and the pen can be deliberately manipulated to give further finish. It may be turned with a quick movement on to the corner of the nib to produce fine hair-line finishing strokes and flourishes. This movement of the pen was used in the lettering on the title page of this book and also in the design opposite.

On the title page the pen was turned on to the corner for the finishing stroke at the foot of the L in "Lettering". In the centre ornament it was turned for the beginning of the cross bar of A and for the beginning and end of Z. In the last line it was turned for the finishing stroke of r in Leicester. These few pen manipulations add to the liveliness of the page.

In the tail-piece opposite the intention was to make a decorative motif. The hair-line strokes have been used in a playful manner to make a design.

Where a text of any length occurs, flourishes and hair-lines should be used with considerable restraint. If overdone they make a page look restless, and the eye will not travel comfortably from line to line.

Slight variations of pressure and differences of pen angle will inevitably occur in spontaneous work. The best MSS show such variations, giving the work a personal quality. Unfortunately printed reproductions can never convey the true qualities of good pen work; students should therefore study original MSS in museums and exhibitions and whenever possible get personal criticism of their work from a good professional.

The student must follow the craft stage by stage, setting himself practical problems as a stimulus to definite thought. He should acquire a sound knowledge of letter forms, and gain a mastery of tools in writing them. He is then ready to develop a personal approach to the subject. Freedom and liveliness are essential qualities of good work, but a disciplined control must come first.

A
BC
ab&cd
XY
Z